examining the visual culture of corporate identity

Contents

introduction	**004**
2gd	**009**
philippe apeloig	**017**
bark	**025**
base	**033**
cahan associates	**041**
epoxy	**049**
imaginary forces	**057**
foundation 33	**065**
graphic thought facility	**073**
iso	**081**
the kitchen	**089**
open	**097**
sagmeister inc	**105**
sea	**113**
segura inc	**121**
spin	**129**
research studios	**137**
alexei tylevich	**145**
julian morey	**153**
why not associates	**161**
credits	**170**

IdN Special 03:
Examining the Visual Culture of Corporate Identity

First published in 2003 by
Systems Design Limited
The publisher of IdN magazine

Shop C, 5 - 9 Gresson Street,
Wanchai, Hong Kong
Tel (852) 2528 5744
Fax (852) 2529 1296
www.idnworld.com

Copyright 2003 by systems design ltd. All rights reserved. No part of this publication may be reproduced, stored in a retreiveal system or transmitted in any form or by any means, electronic or mechanical, including photocopying, recording or any information storage and retrieval systems, without permission in writing from the owners.

While every effort has been made to ensure the accuracy of captions and credits in this book, Systems Design Ltd. does not under any circumstances accept any responsibility for errors or omissions.

Printed in Hong Kong

introduction

This is an extra-special "special edition" of *IdN*, which has been guest–produced by Chris Kelly of London's Mono design studio. His brief? To take a fresh look at the visual culture and language of corporate identity.

Art director Kelly approached 20 leading international creatives in the field of visual communication to respond to the question: "What is corporate identity?" The result is a collector's edition of *IdN* that presents a powerful line-up of cutting-edge identity from the world's leading graphic designers, one that challenges the very definition and form of the subject.

Identity is not an invention of the 20th century: making marks to identify ourselves to others has been part of human culture for thousands of years. Kelly points to the example of Transylvanian potters, who would inscribe personal identification symbols on bowls and other objects, and he says there is also evidence of identity in antiquity: Ancient Egyptian, Greek and Roman artisans uniquely carved their marks into works for identification purposes. As did Native American-Indians, who would carve ancestors and other characters on to heraldic poles (gyáa-aang) to use as symbols of their identity.

Ancient religious sects also developed a wide range of symbols and identities that are still in use today: the Judaic Star of David, the Islamic Crescent Moon and the Christian Cross, for example. In medieval Europe, heraldry was used as an emblematic form of individual identification: knights would paint their shields to distinguish themselves from one another. This practice soon spread to other areas of medieval society, including the church, secular corporations and the merchant classes.

Trademarks began being used by guilds during the Renaissance for masons and craftspeople, says Kelly. This evolved and eventually became widespread as a means of identifying one guild from one another. However, it was the rise of industrialisation, with its manufactured goods, that fortified the development of logos and trademarks as we know them today.

The postwar capitalist economic structure that emerged out of the technological advances of World War II allowed for a huge expansion of the economy. As consumers became more aware of the choices that they now had, companies began to explore how they could create individual marks to be recognised by. Kelly recalls that there were many 20th-century graphic designers who worked to give the new corporations a mnemonic identity. Pioneers such as Paul Rand, Hans Schleger, Herbert Matter, Chermayeff and Giesmar, and Lester Beal, to name but a few, were extremely successful in applying a variety of solutions to solving identity problems for large corporations such as AT&T (Saul Bass) and IBM (Paul Rand).

Our 20 contributors from around the world have each responded to this book in their own personal way, showing us how they apply a variety of solutions to solving identity design problems, what these mean to them and where it is all going.

The result is a fresh insight into how today's exponents of visual communication define in their own terms the visual language of corporate identity. The vivacity of each contributor has filled this special edition with vibrant and powerful work. This book will hopefully dispel the myth for many that corporate identity is the less creative area of graphic design. "As companies are evolving and changing, so is the way we as designers are working to help them by breaking down boundaries ourselves," says Kelly.

This special edition does not pin-point

any particular definitions of what identity has become — its purpose is to question rather than define. And a diverse and distinguished group of designers in the vanguard of their profession has submitted an eclectic mix of work in that pursuit. They are:

2gd from Copenhagen, Philippe Apeloig from Paris, Open and Sagmeister Inc. from New York, Cahan Associates from San Francisco, Imaginary Forces and Alexei Tylevich from Los Angeles, Segura Inc. from Chicago, Epoxy from Montreal, ISO from Glasgow, Base, with offices in New York, Barcelona and Brussels, and from London, Bark, Foundation 33, Graphic Thought Facility, The Kitchen, SEA, Spin, Research Studios, Julian Morey and Why Not Associates.

The outcome is a visually and textually rich publication that will allow readers to explore the many different notions of corporate ID jostling for acceptance in today's design world and inspire them in their own efforts in this field. Hopefully, this special "special edition" will last for as long as it takes for another revolution in the conceptualisation of this subject to take place.
Trademarks began being used by guilds during the rennaisance for masons and craftspeople. This evolved and eventually became widespread as a means of identifying each guild from one another. However it was the rise of industrialisation with its manufactured goods that fortified the development of logos and trademarks as we know them today.

The postwar capitalist economic structure which emerged out of the technological advances of ww2 allowed for the expansion of economy. As consumers became more aware of the choices that they now had companies began to explore how they could create individual marks to be recognised by.

There were many 20th century graphic designers who worked to give the new corporations a mnemonic identity. Pioneers such as Paul Rand, Hans Schleger, Herbert Matter, Chermayeff and Giesmar, Lester beal to name but a few were extremely successful in applying a variety of solutions to solving the problems for large corporations such as AT&T (Saul Bass) and IBM (Paul Rand) .

The twenty contributors from around the world have each responded to this book in their own personal way. Showing us how they apply a variety of solutions to solving identity design problems. What it means to them and where it is going.

The result is a fresh insight into how today's exponents of visual communication define in their own terms the visual language of corporate identity. The vivacity of each contributor has filled this special edition with vibrant and powerful work. This book will hopefully dispel the myth for many that corporate identity is the less creative area of graphic design. As companies are evolving and changing, so is the way we as designers are working to help them by breaking down boundaries ourselves.

This special edition does not pinion definitions of what identity has become alternatively its purpose is to question rather than define.

identity: →

idn special 03:
examining the visual culture of corporate identity
introduction

the
individual
characteristics
by
which
a
person
or
thing
is
recognised

idn special 03:
examining the visual culture of corporate identity

2gd

idn special 03:
examining the visual culture of corporate identity
2gd / copenhagen

2gd

The time we live in, and the speed at which visual information fluctuates through our consciousness, decide what gets noticed or not. It is therefore important to find visual markers that signal direction and meaning. The mass of information challenges our ethics and our ability to make our own selections. The knowledge of this is increasing in late-modern consumers, and they can therefore not be expected to remain loyal to established brands and identities. In its place a marked-based pluralism appears, only adding to the sense of constant change. We see it as our responsibility to work out flexible methods and strategies to utilise this situation to our common good. Eleven aim to make identities a guiding resource, which creates clarity and energy. We base our work on an ideology that views style as the surface of meaning, and meaning as the essence of style. This two-sided strategy directs itself toward the visual aesthetic of the surface, its signals and expressions. As well as the involvement and awareness of the client in the definition of the substance of the identity we jointly create.

blink/metaphorical identity

Corporate identity has become a natural part of the complex communications process between the product or service provider and the consumer. The concept of identity was once regarded as a permanent thing, something synonymous with the industrial category to which a company belonged. The current trend away from inflexible and restrictive corporate identity has its roots in two factors: fashion, and sophisticated consumerism. Fashion has an immediate and visible impact on the development of corporate identity, but it is the consumers' increased awareness of symbolic meaning that has had the greatest influence on the companies' choice of expression. BLINK provides services within all types of photographic productions. BLINK work with photographers and clients within the commercial-, music- and fashion industry. Their goal is to manage the production through all its phases, in order to give our clients the opportunity to focus on the artistic and creative outcome.

Today, people are far more sensitive towards the atmosphere and content of the messages communicated by corporate images, particularly in the business in which BLINK operates. In Eleven's identity creation, we have produced a more metaphorical image rather than a concrete symbol, whether expressed through writing, illustrations, colours or photographs. This expression is intended to emphasise BLINK's skills, with the help of its own production, and is reinforced by an atmospheric choice of colours.

representation of identities

ToC.2GDIV — Introduction to the strategy of aesthetic creation as a process of pendular reflection and expression producing an agenda for the representation of identities. This Eleven project is the result of a process involving opposing methods and different individuals. From the outset the idea was to reach common ground between graphic representation as form and textual meaning. The viewpoints on design, the work process, and the quality of the product that were expressed during this process were recorded and used as the raw material in creating text, graphics, and graphs. The final result is a reflection upon this process as well as a recording of it.

ToC.2GDIV is a conceptual work of design-art and a design manifest. It elaborates on the theme of the relation and the tension between human recognition and the complexity of reality. As a consecutive process originating in these two concepts ToC.2GDIV documents its own genesis. ToC.2GDIV consists of two elements, each of them documenting different phases in its story of creation: The first phase in this process was the conceptualisation and elaboration of ideas, which took the shape of words and combinations of words, i.e. representations of meaning. This phase is documented in a book. The second phase was the creation of a design solution corresponding to the ideas expressed in the book. This solution took the shape of an installation.

danske designere/designless identity

The trade association "Danske Designere" is the mouthpiece of the Danish design industry. It is founded on a defined design policy, with the accent on design as a tool for change, public investment in design as an economic tool, design as a solution model in relation to abstract issues, and education and research in the sphere of design. Via its participation in political and professional design discussion forums at regional, national and international level, Danske Designere helps to place design on the agenda. Under the slogan "Design can change everything", Danske Designere seeks to make an impact as a debate-creating body. "A network which does not define what design is, but which encourages people to ask questions about where the limits of design actually go."

Eleven has interpreted this as a question of not getting in the way. Any approach to form would compromise this intention. Colour would drown out its character. Accordingly, instead of moving into the task and losing itself in obstacles, Eleven pulled back, thus creating a common space in which it is the individual that fills out the frame. The core of this idea is the designless space: a potential that awaits realisation. This, however, also gives rise to the open question of how far you can go before the quest becomes banal. The two rectangles form a timeless reminder that no definition of (good) design has ever been made. The spaces await filling in, and the task of Danske Designere is to create a debate on the manner in which this should be done. Like twins, the spaces represent the dualities of design and politics, designer and consumer, form and content. Inseparable and constant, they act as comments on the role of design in society and in our times. But they are also unpretentious and humourous, in recognition of the fact that design is never an event in itself. Danish Designers was solved in collaboration with E-types.

representation of identities

11

idn special 03:
examining the visual culture of corporate identity
2gd / copenhagen

representation of identities

idn special 03:
examining the visual culture of corporate identity
2gd / copenhagen

representation of identities

WORK
IS
ENLIGHTENME[NT]

CULTURE IS THE MEANS FOR RETAINING THIS CONDITION

idn special 03:
examining the visual culture of corporate identity
2gd / copenhagen

blink identity

blink identity

15

idn special 03:
examining the visual culture of corporate identity
2gd / **copenhagen**

danske designere identity

idea

Focus on the frame
The content is identified by the choice of pictures. Danske Designere is a forum for debate, a network that does not define what design is, but instead challenges its members to question the limits of design.

The rectangles also represent the designless place: a possibility waiting to be realised.

Word - d + ■ = wor■ = surprising an■ obvious

logotype - ■k

■anske ■esignere

logotype - uk

■anish ■esigners

combination

■anske ■esignere ■anish ■esigners

member of ■anske ■esignere

m■■
■anske ■esignere

m■■
■anish ■esigners

colour

starting point

■esign is a knowle■ge-creating process
We stan■ on the threshol■ of the global knowle■ge economy, in which con■itions will be ra■ically ■ifferent for business, compare■ to the in■ustrial society that we know. Human resources such as knowle■ge, creativity an■ enthusiasm are acquiring ever greater significance for the success of a company.

■k21. The ■anish government's business policy.

■esign is liberating

I■ea	■esign is a special perspective which shoul■ be brought into consi■eration in the processes of society.
■iscourse	New energy an■ possibilities in pro■uction an■ in society.
Institution	■esign as metho■ an■ as a way of seeing the worl■, the ■esigner as a consultant.
Organisation	The learning network, consultancy.
Transformation	Better processes an■ pro■ucts through ■esign

■esign can change everything

16

idn special 03:
examining the visual culture of corporate identity
2gd / copenhagen

philippe apeloig

idn special 03:
examining the visual culture of corporate identity
philippe apeloig / paris

philippe apeloig

We are all fascinated by logos: both designers and non-designers. We are all constantly craving the new, for a label which guarantees a certain quality. Unconsciously, our bodies become the support for the visual identity of large corporate companies. We are all proud to carry a mark on our clothes. One may think of people's enthusiasm in wearing T-shirts, caps, bags, pants, etc., with sneaker logos. In our consumer society, marks become trends. They are symbols of belonging to a group. Most young people will search for a mark that identifies with their tastes and their link to a certain social group. For example, the logos for Nike, Puma, and Adidas, work like hieroglyphics or a kind of modern code. They start as a logo, then grow bigger in the development of the brand, ranging from the most common business card, to the most sophisticated stores.

On one end of the spectrum, we have the compulsive attitude of the average consumer who crave different logos according to different trends. It is a bulimia of marks. At the other end, are the designers who feel jaded and think that every possibility has been considered in terms of visual identity, therefore giving rise to the thought that corporate identity is the less creative area of graphic design. It seems that no logo can be new, remarkable, dynamic challenging enough. Is design reaching its limit of creation? Or will designers supersede the limitations of design?

Because new technology brings non-stop confrontation of images and symbols, through the internet and other means, it seems that new logos are more difficult to create. New technologies are great tools, but no one will dare to overestimate the effect of this technological revolution.

A corporate ID can be subjected to the conformity of trends. Following a trend and agreeing with the general consensus hinder us to invent and create new things. Trends deceive people into thinking certain things to be modern and hip, and render us followers, rather than innovators. There is nothing more violent than trendy corporate ID.

A good corporate ID must have an element of surprise, but also remain appropriate to the subject. A designer must predict the survival of his logo through time, by analysing the way his logo will be used and how it will be applied. A good and successful corporate identity cannot be created without a well-crafted logo. This is the foundation of any brand. The rest can be decoration, ornamentation or just plain fun. But the serious and solid aspect of a corporate identity starts with a strong logo.

Designing a logo is the most abstract and probably the most intellectual way of thinking design. A logo must be light, recognisable, new, and fresh. With an economy of means, a designer should be able to convey his/her message in the most essential and economical manner. The logo has to become a monogram; like a footprint of an animal, one should be able to recognise who passed there. A logo is not only a shape; it carries a concept. A good logo combines typographic design with a balance between shapes and counter-shapes. Searching for simplicity does not mean settling for less, but rather looking for sobriety. Balance is the key word.

In designing logos, one must keep in mind that the first idea might not be the best one. In the design process, there is no need to jump into details immediately. However it is the detail, which sometimes makes the logo more specific, original, and unique to itself.

To emphasise the creative aspect, I dare to say that in many ways a logo is a two-dimensional sculpture. It is a silhouette of a three-dimensional object, which means that designers must work like sculptors, taking care of volume and space. One of the first sculptors who dealt with the reduction of details to achieve the most recognisable shape is Constantin Brancusi. His abstract bird and the no end column come to mind; these pieces go beyond simple representation and reach the goal of interpretation without losing symbolism. It also makes me think of Alberto Giacometti's sculptures. For Giacometti, sculpture is meant to "take off" and not to add more. Logo design is precisely this, a "stripping off" of all the non-essential and keeping the essential.

My method of designing a logo is a process of many steps. I explore different solutions and invent something. The starting point may deal with a geometrical shape, which moves toward a more conceptual idea. The issue is to solve a communication problem. The goal is to turn the idea into reality. I evaluate the target and try to find the most objective solution. I am not afraid to reach a classical solution for one project and the most avant-garde solution for another.

Designing a logotype is a movement and transformation. It is about reaching a visual communication. For that reason, applying a single logo over and over again, does not make it outdated in any way. Perhaps it is exactly the opposite: it represents the most up-to-date rigorous way of thinking design.

idn special 03:
examining the visual culture corporate of identity
philippe apeloig / paris

identity for the musée des beaux-arts de tours

MUSÉE ◆ DES ◆ BEAUX -ARTS TOURS

idn special 03:
examining the visual culture corporate of identity
philippe apeloig / paris

poster for the musée des beaux-arts de tours

MUSÉE DES BEAUX -ARTS TOURS

saison 2003 2004

- 18, place François Sicard
- 37000 Tours
- T. 02 47 05 68 73
- ouvert tous les jours
- sauf le mardi
- 9h–12h45 et 14h–18h

20

idn special 03:
examining the visual culture corporate of identity
philippe apeloig / paris

poster for the musée des beaux-arts de tours

En collaboration avec le
Centre International
de la Mélodie Française –
Académie Francis Poulenc

Exposition
5 juillet – 28 septembre
2003

HOMMAGE
GABRIEL
FAURE

18 place François-Sicard
Tours
T. 02 47 05 68 73

MUSÉE
· DES ·
BEAUX
-ARTS
TOURS

21

idn special 03:
examining the visual culture of corporate identity
philippe apeloig / paris

identity for rose & fafner

identity for rose & fafner

idn special 03:
examining the visual culture of corporate identity
philippe apeloig / paris

iuav istituto universitario di architettura di Venezia logotype 2002

idn special 03:
examining the visual culture corporate of identity
philippe apeloig / paris

bark

idn special 03:
examining the visual culture of corporate identity
bark / london

bark

A mark {of something}, a symbol {to stamp}, a logo {to burn}, a brand {to survive}. These are the elements, these are the necessities for corporate/commercial success and progression. This is our visual culture and it is all our fault. Designers are responsible and accountable for how society visually pulls and how individuals are persuaded, desuaded and encouraged to engage. To us, identity is a complex subject. With corporate identity we approach a project with appropriateness vividly at the forefront of the creative process. Not every identity needs the same elements; every identity represents something or someone that has no precedent.

It is part of our role to assess the correct kind of elements required to reflect the product or service or individual and then to create them and apply them. In some cases, all the elements are required and in others only one.

The project shown here is a corporate identity for an architectural company that mainly develops buildings and properties without commission; they generate investment and design and renovate themselves. The focus of their work is within urban environments; believing city living to be important and to pursue sustainable development without creative compromise.

We developed an identity that can be a branding/logo device but also allowed this design to become organic and textural. This treatment reflects the positive outlook of the company through colour and visual growth.

For some promotional material we juxtoposed the "mapping" texture with a mix of harder and more natural images of urban environments. We are showing the company attitude visually by growing the identity upwards and outward.

VARIATIONS

LOGO / MARK _ POSITIVE OVER NEGATIVE

LOGO / MARK _ NEGATIVE OVER POSITIVE

60%
80%
10%
30%
60%
80%
10%
30%

LOGO / MARK _ SIZE SCALE

PHY _ SIZE SCALE

27
idn special 03:
examining the visual culture corporate of identity
bark london

identity for noo age

idn special 03:
examining the visual culture of corporate identity
bark / london

idn special 03:
examining the visual culture of corporate identity
bark / london

abstract of identity
bark / london

idn special 03:
examining the visual culture corporate of identity
bark / london

idn special 03:
examining the visual culture of corporate identity
bark / london

idn special 03:
examining the visual culture of corporate identity
bark / london

base

33
idn special 03:
examining the visual culture of corporate identity
base / new york

base

This is Base. A studio based in 3 cities (BaseBRU in Brussels, BaseBCN in Barcelona and BaseNYC in New York) and specializing in creative direction, art direction, graphic design, brand positioning, brand naming, print advertising, web design and motion graphics.

We like straight-forward, bold, clear visual concepts. We believe that identity work is about making simple and basic choices.

idn special 03:
examining the visual culture of corporate identity
base / new york

Ice identity

**Identity?
You pick a colour.
You stick to it.
And you tell everybody
it is yours.**

35

idn special 03:
examining the visual culture of corporate identity
base / new york

ps identity

idn special 03:
examining the visual culture of corporate identity
base / new york

beople identity

Identity?
You pick a shape.
You stick to it.
And you tell everybody
it is yours.

idn special 03:
examining the visual culture of corporate identity
base / new york

museum of modern art in new york identity

Identity? You pick a system. You stick to it. And you tell everybody it is yours.

38

idn special 03:
examining the visual culture of corporate identity
base / new york

bozar identity

Identity?
You pick a typeface.
You stick to it.
And you tell everybody
it is yours.

Identity?
You pick good pics.
You stick to them.
And you tell everybody
they are yours.

idn special 03:
examining the visual culture of corporate identity
base / new york

cahan
associates

idn special 03:
examining the visual culture of corporate identity
cahan associates / san francisco

cahan associates

When envisioning the future of brands, the merit of an identity will continue to be based on not only its emotional and visual properties, but also its financial strength. The greatest designer can create the most brilliant logo, but what relevance will it have if no one sees it? "A trademark is created by a designer, but made by a corporation," Paul Rand, The Trademark, from 'A Designer's Art' 1985. Finding companies that understand the benefit of branding, and companies that are willing to support that financially, will continue to be a designer's greatest challenge.

86

43

idn special 03:
examining the visual culture of corporate identity
cahan associates / san francisco

24

66

44
idn special 03:
examining the visual culture of corporate identity
cahan associates / san francisco

45

idn special 03:
examining the visual culture of corporate identity
cahan associates / san francisco

46
idn special 03:
examining the visual culture of corporate identity
cahan associates / san francisco

idn special 03:
examining the visual culture of corporate identity
cahan associates / san francisco

01 Sherwin Poorsina, 31, Print Sales, San Francisco, California
02 Sean Williams, 35, Bartender, San Francisco, California
03 Curtis, 32, Bartender, Oakland, California
04 Joe, 28, IT, San Francisco, California
05 Scott Rutenburg, 40, Graphic Artist, Sausalito, California
06 Sally, 47, Computer Programmer, Walnut Creek, California
07 Robbie, 62, Retired, Los Angeles, California
08 P. Pattison, 55, Unemployed, Montara, California
09 Bonnie Powers, 35, Consultant, San Francisco, California
10 Gwen Perry, 32, Bartender, San Francisco, California
11 Peggy Nicholson, 42, Window Decorator, San Rafael, California
12 Gerry Murphy, 50, Iron Worker, Brooklyn, New York
13 Renzo, 35, Manager, San Francisco, California
14 Dave, 31, Finance, Oakland, California
15 James McGurin, 70, Retired, New York, New York
16 Katie Cole, 24, Beauty Artist, Oakland, California
17 Bella Banbury, 30, Account Director, Alameda, California
18 Judie Mejia, 33, Coach, San Francisco, California
19 Rod, 38, Homemaker, San Francisco, California
20 Rob Schleihauf, 27, Teacher, San Francisco, California
21 Rebecca, 26, Marketing, San Francisco, California
22 Rob Roberson, 38, Sales, San Francisco, California
23 Chris Rainsford, 47, Window Trimmer, Marshall, California
24 Chuck, 37, Project Accountant, Oakland, California
25 Andre Welsh, 21, Student, San Francisco, California
26 Amy Chan, 30, Clerical, San Francisco, California
27 Julie H., 30, Youth Development, Red Hook, New Jersey
28 Stephen Banbury, 34, Marcom Director, Oakland, California
29 Trevor Shoemaker, 29, Healthcare, Oakland, California
30 Lori, 33, Franchise Owner, San Francisco, California
31 Lauren M. Fichera, 24, Teacher/Sculptor, New York, New York
32 Lanie, 23, Pizza Delivery Girl, Oakland, California
33 Dan Bruce, 24, Musician, Oakland, California
34 Mik Torris, 46, Consultant, San Diego, California
35 Rick Pinheiro, 39, Project Manager, San Francisco, California
36 Ramiro Darien Espada, 61, Public Speaker, Forest Hills, New York
37 Harold, Unemployed, Oakland, California
38 Ken, 25, Teacher, Oakland, California
39 Ben, 24, Sales, San Francisco, California
40 D., 28, Gardener, Oakland, California
41 Angela Thomas, 41, Preschool Teacher, Oakland, California
42 Jack S., 33, Planner, Berkeley, California
43 Frankie, 27, Barista, San Francisco, California
44 Dan Graves, 33, Consultant, San Carlos, California
45 Fa Ching, 58, Unemployed, San Francisco, California
46 Liz Giles, 25, Real Estate, New York, New York
47 Judy Dujols, 31, Babysitter, Mill Valley, California
48 Bryan Hames, 30, Sales, San Francisco, California
49 Mike Picone, 37, Music, New York, New York
50 Lindsay Dorroh, 23, Nanny, Berkeley, California
51 Tracey Thomas, 23, Teacher, New York, New York
52 Jennifer Erskine, 29, Plant Ecologist, San Francisco, California
53 Jake, 28, Public Health, Atlanta, Georgia
54 Eric Barnachen, 22, Bank Teller, Carson, California
55 Laurie Carrigan, 39, Design Director, Redwood City, California

56 R. Beauparlant, 30, Programmer, San Francisco, California
57 Joanna, 21, Sales, San Ramon, California
58 Bob Dinetz, 40, Graphic Designer, San Francisco, California
59 Betsy Branden, 28, Designer, San Francisco, California
60 K. Boyle, 23, Unemployed, Staten Island, New York
61 Dennis McCartin, 60, Furniture Store Manager, New York, New York
62 Chris Renoux, 31, Training Specialist, Oakland, California
63 Barbara Brennan, 55, Art Teacher, New York, New York
64 Nita Beuare, 34, Public Health, Atlanta, Georgia
65 Michael Barden, 31, Bartender, San Francisco, California
66 Jim Conry, 37, Electrician, Brooklyn, New York
67 Jeff Yoshimi, 33, Post Doctoral Researcher, San Diego, California
68 Chris, 30, Business Development, Oakland, California
69 D. Brennan, 32, Bartender, San Francisco, California
70 Cindy, 19, Waitress, San Francisco, California
71 Dan Metzler, 22, Self Employed, Oakland, California
72 Tom Doonan, 64, Civil Servant, San Francisco, California
73 Arzo Zoey Homayun, 22, Bartender, San Francisco, California
74 Tom M., 50, San Lorenzo, California
75 Zen, 36, Student, New York, New York
76 Steve Romanko, 34, Filmmaker, San Francisco, California
77 Casey Dolan, 25, Bartender, Oakland, California
78 Sharrie Brooks, 40, Graphic Designer, San Rafael, California
79 Sarah, 22, Bartender, San Francisco, California
80 Austin Howe, 44, Advertising, Portland, Oregon
81 Meghan McCartin, 28, Bartender, New York, New York
82 Curtis Boyce, 22, Clothing Sales, San Francisco, California
83 Kevin Roberson, 36, Graphic Designer, San Francisco, California
84 Bridget Lawrence, 26, Receptionist, San Francisco, California
85 Jennifer Lies, 31, Website Coordinator, San Francisco, California
86 Dave, Sales, Oakland, California
87 Dave Hunger, 41, Account Manager, Oakland, California
88 Brian Muerle, 40, Teacher of Industrial Safety, Oakland, California
89 B. Patrick, 43, Make-Up Artist, San Francisco, California
90 Melanie MacInnis, 34, River Guide, Berkeley, California
91 Todd Harwood, 33, Musician, New York, New York
92 Angela C., 28, Homemaker, Berkeley, California
93 Crystal Phillips, 33, IT, San Francisco, California
94 Jesse H., Davis, 30, Bartender, Oakland, California
95 Jasmine, 25, Massage Therapist, Oakland, California
96 Paul Dent, 43, Architect, San Francisco, California
97 Jesus Hernandez, 42, Bartender, Daly City, California
98 Dawn Robinson, 28, Child Care Professional, San Francisco, California
99 Rachel Briles, 24, Stripper, Oakland, California
100 Lauren Cromwell, 24, Account Coordinator, Belvedere, California
101 Kees Briggs, 29, Sales, San Francisco, California
102 Heather Hitchcock, 33, Print, San Francisco, California
103 Frank Huang, 35, Karaoke Host, San Jose, California
104 Sai Jai Poorsina, 31, Print Sales, South San Francisco, California
105 Christopher Chan, 5, Student, San Francisco, California

idn special 03:
examining the visual culture of corporate identity
cahan associates / san francisco

epoxy

idn special 03:
examining the visual culture of corporate identity
epoxy / montréal

epoxy

At Epoxy, we believe openness, flexibility and multi-disciplinary are the keys for our approaches toward "corporate identity". Since every single client and project have their own unitness and complexity, we often found ourselves exploring the solution from various different entrances. Understanding our client's need is vital. The goal is to help our clients communicate with their audience by means of design problem solving in different areas, range from traditional medium such as print or television to new medium like web or even handheld devices.

The TV spots stand out because they add a "break in the commercial break". Like the overall campaign, we wanted to get away from the usual, sterotype images seen so often in beer commercials, those half-naked teenagers jumping around on a beach pounding rock music, and go in the opposite direction: no party, no rock'n roll, no voice over, and not even one image of the product itself. It was a breath of air in an overcrowded advertising environment; and, even though we never actually saw the product, the impressionistic visuals and aural style quickly became associated with the product.

The music was composed first; and the visuals were created with the music in mind, which is why the visuals are so well integrated into the campaign. The whole mood was inspired by the music.

We also had a major restriction with the bottle format because in Quebec, there is a standard bottle for all the beers made by major breweries, including Labatt. The bottles are all the same size, form and colour: brown. Since Vodkice is an alco-malt beverage (not a vodka-base drink), we had to use the standard brown bottle. So it was quite a challenge to give Vodkice a fresh look, innovative style and attitude using that bottle.

cozmo forest and ocean tv spots

idn special 03:
examining the visual culture of corporate identity
epoxy / montréal

cosmo packaging and promotional material

vodkice promotional material, packaging and vodkice billboard

54

idn special 03:
examining the visual culture of corporate identity
epoxy / montréal

vodkice digital love tv Spot

55

idn special 03:
examining the visual culture of corporate identity
epoxy / montréal

cozmoland tv spot

idn special 03:
examining the visual culture of corporate identity
epoxy / montréal

imaginary forces

idn special 03:
examining the visual culture of corporate identity
imaginary forces / los angeles

imaginary forces

Historically designers have understood movement as the travel of "a moving eye in space". Typography and identity in both in their realisation and conception, have been mostly understood as static.

Architect Greg Lynn gets to the heart of this when he describes the difference between "animation" and "motion" in his critique of architecture today: "Animation is a term that differs from, but is often confused with, motion. Where motion implies movement and action, animation suggests animalism, animism, evolution, growth, actuation, vitality and virtuality."

For the Sci-Fi Channel re-design IF collaborated with architect Greg Lynn, using animation for the generation of an identity dynamically.

Rather than being conceived as stationary and inert, identity is seen as highly flexible and mutable in its dynamic evolution through motion and transformation.

The design process becomes literally and conceptually animated, mandating a more improvisational design attitude.

The mark, identity and typography are constantly unfolding/becoming over time.

overview of scifi channels

SCIFI CHANNEL :: NETWORK REDESIGN
IMAGINARY**FORCES** + GREG LYNN FORM
© IMAGINARYFORCES + GLFORM 2001

59

idn special 03:
examining the visual culture of corporate identity
imaginary forces / los angeles

cyber channel

/ technological surfaces made up of collections of cells /

60

idn special 03:
examining the visual culture of corporate identity
imaginary forces / los angeles

fantasy channel

FANTASY *::* Extravagant & unrestrained forming of mental images, esp. wondrous or strange fancies, imagined sequence of events provoked by an unfulfilled psychological need, abnormal or bizarre sequences of images e.g.: hallucination

Outside/ Forest / Localized architecture / Terrestrial (surfaces that grow) / Objects World materialize based on thought / Architecture based on emotional need / Forms around you / Surfaces that grow, flourish, augment, blossom, amplify / Luscious Ornate / Rich / Flamboyant

61

idn special 03:
examining the visual culture of corporate identity
imaginary forces / los angeles

horror channel

HORROR ∷ overwhelming shuddering fear and anxiety created by something shocking, terrifying or revolting.

InsideOut / House / Confined spaces / Thickening air / Lliquefying ground Suffocating / Warm red / Unstable ground / Slimy / Thick / Gluttonous / Semi fluid ground / Dramatic changes in scale and size / Untrustworthy / Shifting Transparent planes / Revealing alternate worlds / Scenarios

idn special 03:
examining the visual culture of corporate identity
imaginary forces / los angeles

paranormal channel

idn special 03:
examining the visual culture of corporate identity
imaginary forces / los angeles

channel identities

cult

cyber

fantasy

horror

paranormal

space

suspense

idn special 03:
examining the visual culture of corporate identity
imaginary forces / los angeles

foundation 33

idn special 03:
examining the visual culture of corporate identity
foundation 33 / london

foundation 33

Foundation 33 is a design studio formed in March 2000 by Daniel Eatock, a graphic designer and Sam Solhaug, an architect. Each partner's expertise in his respective vocation is combined with the other's to form a multi-disciplinary studio practice grounded in a rigorous and conceptually motivated design methodology. Foundation 33 does not rely on market research and current trends but makes engaging work, which is relevant to the client and captivates the mindset of the audience. Foundation 33 maintains a conceptual, strategic and considered approach to briefs, brands and products so that design and its communication always remain integral to each other.

idn special 03:
examining the visual culture of corporate identity
foundation 33 / london

big brother 2

idn special 03:
examining the visual culture of corporate identity
foundation 33 / london

big brother 3

big brother 3

69
idn special 03:
examining the visual culture of corporate identity
foundation 33 / london

big brother 4 / landmarks

70

idn special 03:
examining the visual culture of corporate identity
foundation 33 / london

big brother 4

idn special 03:
examining the visual culture of corporate identity
foundation 33 / london

celebrity big brother

idn special 03:
examining the visual culture of corporate identity
foundation 33 / london

graphic thought facility

idn special 03:
examining the visual culture of corporate identity
graphic thought facility / london

graphic thought facility

I still love a lot of the logo's that I spent my time pouring over at college. Yamaha, the Woolmark, UPS (recently f**ked up). I don't think they are invalid, a brand can be revitalized appear less monolithic, softer, whatever — without having to inflict these metaphors directly upon a well crafted and established mark. However, for us to approach an identity in the same terms as these "mid century classics" does feel like something of a pastiche, like trying to be a non-ironic contemporary progressive rock band, possible maybe, difficult, yes, relevant, not sure.

With the above attitude it was difficult when we were approached by long standing client Habitat to reappraise their mark. To alter it for reasons of "image" our answer was no, however alterations where necessary for complicated business/legal reasons. In the end, although maybe a little deflating for our ego, its success was measured by nobody really taking issue with the alterations.

Most of our work is for institutions of a small enough size to allow us to specify all matters of application and production, allowing brand values to be sustained by consistent attitude and physical qualities rather than the constant visibility of a mark. A brand defined by many suggestions, not distilled into a single element.

habitat logo

idn special 03:
examining the visual culture of corporate identity
graphic thought facility / london

design museum identity

DESIGN MUSEUM ®

76

idn special 03:
examining the visual culture of corporate identity
graphic thought facility / london

jo gordon identity ideas

JO GORDON

JO GORDON

GORDON

JO Gordon

JO GORDON

GORDON

77

idn special 03:
examining the visual culture of corporate identity
graphic thought facility / london

identity for frieze art fair

idn special 03:
examining the visual culture of corporate identity
graphic thought facility / london

identity for little i
graphic thought facility / london

LITTLE_i

idn special 03:
examining the visual culture of corporate identity
graphic thought facility / london

logo unit for carnegie identity

CARNEGIE INTERNATIONAL 2004–5
9 OCTOBER 2004 — 20 MARCH 2005

80

idn special 03:
examining the visual culture of corporate identity
graphic thought facility / london

iso

idn special 03:
examining the visual culture of corporate identity
iso / glasgow

iso

ISO are a design group based in Glasgow. We originally specialised in developing identities for branding television channels and programmes. We now also apply this approach to film titles, commercials, interactive environments and online projects.

The Mesh project has been developed over 3 years and is Channel 4 Television's interactive animation training scheme.

Initially envisaged as a virtual campus that would be visited by trainee digital animators the scheme is focused around the Mesh website — part lecture theatre and library, part screening room.

The identity for the scheme was developed around the concept of a "mesh" from which we extracted a simple 3D environment, populated by the schemes mascots — the Mesh robots. Each year a new super improved model of the Mesh robot is released into the space!

The graphics have been applied to the 4 different versions of the site, TV indents, print and advertising.

The Sub Club is recognised as one of the world's best underground clubs. The club was radically redesigned in 2002 following a fire that gutted the original interior. We were approached to develop a new identity that was sympathetic to its 15 years history but also defined a future vision for the club.

Rather than reduce its identity to a single mark we chose to introduce a modular system — built from graphic patterns and textures that were taken from the new font family we designed for the club. It is this system of abstract graphic elements, which the club is now recognised by.

The system was launched over three months via a 6-part fly posting campaign — each new version directly overprinted the previous layers, which included a roll call of the hundreds of DJ's that had appeared, images of the gutted interior and launch details — history was acknowledged then laid to rest!

mesh poster

83
idn special 03:
examining the visual culture of corporate identity
iso / glasgow

mesh poster
iso / glasgow

idn special 03:
examining the visual culture of corporate identity
iso / glasgow

mesh identity mascots
iso / glasgow

idn special 03:
examining the visual culture of corporate identity
iso / glasgow

identity for sub club

WWW.SUBCLUB.CO.UK

idn special 03:
examining the visual culture of corporate identity
iso / glasgow

sub club pattern

iso / glasgow

6-part poster campaign

88

idn special 03:
examining the visual culture of corporate identity
iso / glasgow

the kitchen

idn special 03:
examining the visual culture of corporate identity
the kitchen / london

the kitchen

Design consultancy the Kitchen has created the identity and logo for the first ever girls only Levi's® store.

Opening in Paris, the store signals the realisation of a new retail strategy for Levi's®, to target female consumers. In contrast to the existing Levi's® stores in which the overall experience is quite masculine, the new store will be more of a boutique environment designed to appeal to the style-conscious, sassy, young female denim shopper.

Working with Bartle Bogle Hegarty, Levi's® advertising agency, the Kitchen was briefed to develop a strong visual identity that would embody a feminine attitude and edgy strength, whilst underpinned by a rock n'roll sexiness. After studying a number of photographs of girls faces, an abstract, silhouetted generic face was created to form the marque. In order to make the girl more distinctive and memorable it was important that her face remained an abstract, illustrative image rather than being too photographic or recognisable as a specific individual.

The overall look and feel of the identity is informed by West Coast psychedelic music posters of the late 60s but reinterpreted with a contemporary feel. The strong magenta colour palette also references the era's use of Pop/Op Art's vibrant colours.

In-store graphics see the Girl's hair curl and grow out from the central logo to extend across the interior walls like flames, further influenced by American dragster graphics. Additionally, the identity system is being applied to window graphics, bags and hoardings.

girls only levi's® store identity
the kitchen / london

idn special 03:
examining the visual culture of corporate identity
the kitchen / london

idn special 03:
examining the visual culture of corporate identity
the kitchen / london

93

idn special 03:
examining the visual culture of corporate identity
the kitchen / london

idn special 03:
examining the visual culture of corporate identity
the kitchen / london

idn special 03:
examining the visual culture of corporate identity
the kitchen / london

idn special 03:
examining the visual culture of corporate identity
the kitchen / london

open

idn special 03:
examining the visual culture of corporate identity
open / new york

open

Trio is a television network that's all about popular culture. They celebrate tv as an art form by featuring a great mix of smart, entertaining and surprising shows that are all part of our shared cultural experience.

We're proud to have had the opportunity to develop a complete network redesign for Trio, built around their new logo (created by design studio Number Seventeen in New York) and designed for use on air, online and in print.

When developing a large-scale identity like this, it's important for us to figure out some fundamental concepts about the organization. Ideas like these then guide every choice we make at every step of the project.

trio is smart.
There's a lot of culture (TV, magazines, movies, bands, websites, etc.) to deal with these days. That's where curators — trusted authorities who share their passions and sensibilities — come in. And Trio is a curator of popular culture.

trio is complex.
What other channel shows Laugh-In and Philip Glass concerts? Leonard Bernstein and Andy Kaufman? "American Mullet" and "Looking for Richard?" Trio's unpredictable programming choices create a surprising viewing experience.

trio is meta.
Today's TV viewers are smart. They know the media and are interested in how it all works. By featuring shows about the media and communicating in new ways, Trio will connect with people that are ready for a new kind of TV.
Everything we've designed for Trio — in motion, on the web and in prin — is made up of some combination of these nine basic elements:

1. tagline
It's a list of three nouns: two are always changing, and the third is always "TV." This way every time Trio identifies itself it's another chance to say what the network is about — not just what Trio is but how Trio thinks.

2. voice
Everything Trio does is a message to its viewers. So why not really talk to them? Direct language like "we think you'll like this" or "heads up" or "this next show is a rerun" exemplifies Trio's inclusive, self-aware spirit.

3. typography
The typographic voice of the network is Tobias Frere-Jones' Gotham, based on vernacular signage in and around New York City. This special version of Gotham has round dots and punctuation to match the dot in the Trio logo.

4. color
Inspired by TV colour bars as well as four-color process, we created a palette with a full range of vibrant colours that relate to each other harmoniously. The only colour missing is pure red — so the red Trio logo always stands out.

5. sound
Many TV networks use a jingle or musical cue as part of their identity. We instead developed a system in which any sound — a musical note, a bird, a motorcycle — repeated three times in a row can represent Trio and its inventive attitude.

6. photography
A big part of the Trio identity is the use of bright full-colour photography and footage to express ideas in unexpected ways. The images contrast nicely with the bright colour palette and stand out from just about everything else on TV.

7. searching
Today people are used to sifting through lots of information to find what they need. For Trio, we devised ways to sort shows by keywords and used scrolling and highlighting to add the energy of the search to the network's identity.

8. transitions
Throughout the identity, circles are used to focus on key information, comment on images and refer graphically to the Trio logo. In the animation, overlapping fields of colour mix to create visual energy at surprising moments.

9. music
By thoughtfully curating a collection of music, Trio can connect with its viewers in another way. Smart music choices demonstrate the network's pop-culture expertise and make the viewing experience a lot more enjoyable.
An identity is not just about a nice logo. It's a way to express what an organization is about through everything it does and everything it says. And that visual language has to be both compelling and flexible for it to work.

With a set of tools like these, anyone who needs to create work for Trio can start with a clear understanding of how the network talks to its viewers. But they still have the freedom to create work that's surprising and new.

The new Trio identity isn't a stylistic makeover. It's an integral part of the network that should last for a long time. For us, this is the best kind of project. Helping an organization be what they want to be is challenging, rewarding and fun.

TRIO sights, sounds, tv.
TRIO art, design, tv.
TRIO heart, soul, tv.

TRIO fact, fiction, tv.
TRIO comedy, drama, tv.
TRIO obsession, compulsion, tv.

TRIO actions, words, tv.
TRIO dance, theater, tv.
TRIO agony, defeat, tv.

TRIO rock, roll, tv.
TRIO heroes, villains, tv.
TRIO stars, co-stars, tv.

TRIO old school, new school, tv.
TRIO setbacks, triumphs, tv.
TRIO best boy, key grip, tv.

TRIO songs, stories, tv.
TRIO war, peace, tv.
TRIO **pop, culture, tv.**

TRIO artists, models, tv.
TRIO reading, writing, tv.
TRIO audio, video, tv.

TRIO lights, camera, tv.
TRIO irony, sarcasm, tv.
TRIO vhs, dvd, tv.

TRIO gossip, scandal, tv.
TRIO coffee, donuts, tv.
TRIO cable, satellite, tv.

idn special 03:
examining the visual culture of corporate identity
open / new york

trio network redesign: ids + show packaging

100

idn special 03:
examining the visual culture of corporate identity
open / new york

trio colour palette

101
idn special 03:
examining the visual culture of corporate identity
open / new york

trio network redesign: endpages + menus

Each weeknight:

8pm (et)
Sessions at West 54th

TRIO pop, culture, tv.

Each weeknight:

9pm (et)
9Sharp

TRIO pop, culture, tv.

Each weeknight:

10pm (et)
Late Night with David Letterman

TRIO pop, culture, tv.

search:
box office

search:
box office

search:
box office

Sun 4pm (et)
TRIO Original
The Blockbuster Imperative

Sun 5:30pm
Face Time with
Kurt Andersen
Peter Bart

TRIO popcorn, soda, tv.

search:
counterculture

search:
counterculture

search:
counterculture

Fri 9am (et)
Rowan & Martin's Laugh-In
Dick Gregory

Fri 9am (et)
TRIO on Tour
Anne Sofie vo
meets Elvis C

TRIO peace, love, tv.

search:
independent

search:
independent

search:
independent

Mon 9pm (et)
Easy Riders/
Raging Bulls
Targets
Boris Karloff

Mon 11pm
Easy Riders/
Raging Bulls
Woodstock D
Part 1

TRIO inspiration, creation, tv.

102

idn special 03:
examining the visual culture of corporate identity
open / new york

trio network redesign: billboards

103

idn special 03:
examining the visual culture of corporate identity
open / new york

trio network redesign: technical difficulties

104

idn special 03:
examining the visual culture of corporate identity
open / new york

sagmeister inc.

idn special 03:
examining the visual culture of corporate identity
sagmeister inc / new york

sagmeister inc.

Even though we also did design a classic logo for Annie Kuan, an Asian fashion designer working in New York, the identity is defined by the materials used. For 10 seasons we have utilised regular newsprint for her catalogues

This idea came solely out of budget constraints. We really only had the money to print a post card. But a friendly designer told us about a really cheap newspaper printer.

We could do the entire catalogue run for a season for under 200 dollars. For the first one we bought wire hangers (2 cents/piece) and corrugated board (12 cents/piece). Got a shrink wrap machine (500 dollars) and the client hired a student to put it all together.

annie kuan letterhead

annie kuan business cards

ANNI KUAN

242 W 38TH ST NEW YORK NY 10018 PHONE 212 704 4038 FAX 704 0651

EW YORK NY 10018 PHONE 212 704 4038 FAX 704 0651

108
idn special 03:
examining the visual culture of corporate identity
sagmeister inc / new york

page from catalogue

ANNI KUAN HAPPILY
INVITES YOU TO THE
FASHION COTERIE
IN NEW YORK CITY

TO PREVIEW THE
SPRING/SUMMER
COLLECTION 2002

FROM SUNDAY SEP. 23
TO TUESDAY SEP. 25 2001
BACK AT PIER 92

REPRESENTED BY

CYNTHIA OCONNOR + COMPANY
141 WEST 36 STREET, SUITE 12A
NEW YORK, NY 10018

TEL 212 594 4999
FAX 212 594 0770

idn special 03:
examining the visual culture of corporate identity
sagmeister inc / new york

page from catalogue

110

idn special 03:
examining the visual culture of corporate identity
sagmeister inc / new york

more pages from catalogue

#2 **YOU & ALL YOUR STORIES**

ME & MY DUMB HAIR

FRONT

> BALLOON SLEEVE SWEATER IN SILK CASHMERE
> ASYMMETRICAL FOLDED SKIRT

BREATHING ON THE BACK OF MY NECK TIL WE BREAK UP

+ IF THAT'S TOMORROW
DON'T EVER WANNA WAKE UP

(ON BED POST) 3/4 BELTED COAT IN WOOL TWEED WITH SHAGGY MOHAIR COLLAR
(ON FLOOR) WOOL TWEED SLITTED TROUSERS IN BROWN, LILAC AND MOSS

111

idn special 03:
examining the visual culture of corporate identity
sagmeister inc / new york

catalogue shrink wrapped in foil

idn special 03:
examining the visual culture of corporate identity
sagmeister inc / new york

sea

idn special 03:
examining the visual culture of corporate identity
sea / london

sea design

beyon is a contemporary office furniture company. The logo reflects their simple, straightforward style. The photography is all about spectacular environments — in this case Tate Modern.

lpa is a leading fashion/advertising photographers agency. As the photographers and their books change so does the LPA identity. This is echoed in the vibrant use of a changing spectrum of colour.

kew is a new high street brand from the Jigsaw group. The simple elegance of the clothes is captured by the style of the logo and Richard Learoyd's beautiful flower imagery.

you is an executive recruitment company that offers a unique personalised service. Their brand is all about words — simple, yet clever words by Howard Fletcher that appeal to, and excite their audiences.

d&ad needed a visual identity for their awards ceremony at Earls Court. Our work for the title sequence and printed materials reflected the set design created by Rasheed Din.

keen, the contemporary furniture company, wanted an brand that reflected the collective nature of their company — six individual and stylistically different designers under the leadership of Charles Keen.

wise buddah is a leading radio syndication collective, specialising in dance music. The brand, covering everything from packaging to studio signage needed to appeal to like-minded music professionals and focused on colour and typography.

beyon identity

Beyon
Business Card
Corporate Brochure
Beam Brochure

115

idn special 03:
examining the visual culture of corporate identity
sea / london

lisa pritchard identity

LISA PRITCHARD AGENCY/
48A MONMOUTH STREET
LONDON WC2H 9EP/
TELEPHONE 020 7240 7877
FACSIMILE 020 7240 7669
LISAPRITCHARD.COM

LPA/

LPA
Lisa Pritchard Agency
Photographic Agent
Business Cards
Postcards
Posters

116

idn special 03:
examining the visual culture of corporate identity
sea / london

LISA PRITCHARD

kew identity

Kew
Logo
Retail Bags

117

idn special 03:
examining the visual culture of corporate identity
sea / london

you logo and business card
d&ad 2001 d&ad awards identity

15 Stratton Street Telephone Mobile
Mayfair 020 7659 0440 07966 205 333
London Facsimile
W1J 8LQ 020 7659 0445

Good to meet you.

Jerom jeromy@ etyou.co.uk
irect

you™

118

idn special 03:
e&amining the visual culture of corporate identity
sea / london

keen logo and product brochures

keen

idn special 03:
examining the visual culture of corporate identity
sea / london

wise buddah logo and cd packaging

wise*
buddah

120

idn special 03:
examining the visual culture of corporate identity
sea / london

segura.inc

idn special 03:
examining the visual culture of corporate identity
segura inc / chicago

segura inc.

The belief that a new "look" will change who you are is the biggest mistake clients seeking identity subscribe to. They often spend large amounts of money, and they do nothing, or very little to change what caused the crack in the first place.

A new logo does not make the company. The company makes a new logo stand for what the claim might be. Any logo can stand for greatness. Apple is the perfect example. We all like it now. But if you think about it, it was just a cheesy low budget mark that has blossomed into representing one of the greatest companies ever to exist. And the logo had nothing to do with it.

On the other hand, there was Audi. A great company with a great logo that almost went out of business in the mid 80s because their cars sucked. The same goes for Harley Davidson. They now both enjoy a powerful place in the "success time-capsule" because those companies stand for greatness in everything they do.

idn special 03:
examining the visual culture of corporate identity
segura inc / chicago

5inch

CUSTOM DESIGNED BLANK CDR'S AND CASES

123

idn special 03:
examining the visual culture of corporate identity
segura inc / chicago

5inch cdr front
segura inc / chicago

5inch.
CUSTOM DESIGNED BLANK CDR'S AND CASES

FINALLY, BLANK CDR'S AND CASES THAT ARE
AS UNIQUES AS THE DATA YOU PUT ON IT.

124

idn special 03:
examining the visual culture of corporate identity
segura inc / chicago

5inch.

CUSTOM DESIGNED BLANK CDR'S AND CASES

1110 NORTH MILWAUKEE AVENUE, CHICAGO, IL 60622
773.862.0291 | INFO@5INCH.COM | WWW.5INCH.COM

You can now get pre-designed, silk-screened blank CDR's that are as unique as the data you put on it, rather than the usual generic and bland "off the shelf" media that's available. This will make you look more professional.

For you recording artists, you can use them as demos of your newest audio excursions. Designers, artists and photographers can use them to showcase their portfolio. Of course, you can also use them to backup your data, transfer files, burn MP3's, video or multi-media presentations, or create a family photo album of your digital shots. We also have blank DVD-r as well as great looking trigger cases.

corbis identity newspaper

idn special 03:
examining the visual culture of corporate identity
segura inc / chicago

corbis identity newspaper

idn special 03:
examining the visual culture of corporate identity
segura inc / chicago

dc comics identity project

idn special 03:
examining the visual culture of corporate identity
segura inc / chicago

spin

idn special 03:
examining the visual culture of corporate identity
spin / london

spin

London based agency Spin were appointed by the Whitechapel Art Gallery to redesign their identity at the end of last year. The brief was to be bolder and more energetic in order to reflect the Gallery's position as a place of influence on modern culture. It needed to connect with a broader UK and international audience whilst retaining a sense of the Gallery's East London location.

Spin's solution uses the triangle as a building block to create the Whitechapel identity. Working on a background grid, the identity has connections to the immediate area in its bold, robust character. The logo also references the intricate geometric shapes used in Islamic art. The combination of the brutal outside shape and light triangular internal construction suggest strength and delicacy at the same time.

Although the logo itself will remain consistent, the ongoing development of the grid and geometric devices will allow the identity to grow in a unique way and respond to different artists and exhibitions at the Whitechapel.

Previous identities have paid homage to the character of the building; the new mark reflects the Whitechapel's future ambition — to continue to show artists that are shaping space and informing culture, and be the destination for seeing the most exciting and challenging contemporary art.

whitechapel

Philip-Lorca diCorcia 07.02-24.08.2003
storybook Life

Whitechapel High Street
+44(0)20 7522 7888
www.whitechapel.org

Aldgate East ⊖

Tues – Sun 11am – 6pm
Thurs until 9pm
Admission free

Media Partner
Wallpaper*
In association with
The Sunday Telegraph

The Whitechapel is grateful for
the ongoing support of

poster

131

idn special 03:
examining the visual culture of corporate identity
spin london

ninety-fortyfive
whitechapel typeface

ABCDEF
GHIJKL1
234567
890abcd
efghijkl

idn special 03:
examining the visual culture of corporate identity
spin / london

ninety-fortyfive
typographic expressions

idn special 03:
examining the visual culture of corporate identity
spin / london

cristina iglesias exhibition poster
& whitechapel magazine cover

idn special 03:
examining the visual culture of corporate identity
spin / london

whitechapel magazine front covers
with band & inside spreads

135

idn special 03:
examining the visual culture of corporate identity
spin / london

franz west poster

FRANZ WEST – WORKS 1973–2003

research studios

idn special 03:
examining the visual culture of corporate identity
research studios / london

research studios

Research Studios is a dynamic, experienced and innovative visual communications and design studio with offices in London, Paris, Berlin and New York, operating across a broad range of commissions and media, from one-off creative projects to complete visual communication strategies. A small team infrastructure maintains a strong human aspect. For each project we work by creating solid systems and constructions over a well researched and rooted foundation or DNA. Over this solidity we then improvise, so as to explore new possibilities while remaining rooted in a clear structure and code — a basic language model. Our approach to design is one of an exploratory process leading wherever we can to constantly evolving solutions focused on a criteria of revealing, not concealing, the underlying control mechanisms evident at the root level of communication. We attempt to actively engage the viewer emotionally and intellectually by confronting them with ambiguous and often incomplete or abstracted images, usually underpinned by a formal typography, which create a dialogue that by necessity can only be completed by the viewers own interpretation, ensuring a fluidity of communication. This can help highlight directly the insubstantiality of consumer culture through a kind of experiential shift, and can often create a vital place of quiet, peace and oxygen.

Made in Clerkenwell is an open weekend and design fair held by the Clerkenwell Green Association, a unique charity working to maintain and promote fine craft and design skills, that offers studio space to designers and skilled craftspeople in the area. Over the weekend studios were open to the public to showcase the work created by the designers which includes fashion design, ceramics, textiles and jewellery. The main promotion piece for the event is the fold out flyer, the delicate, intricate spiral font was designed and used to give a feel of the precise work that goes into the pieces designed by the skilled craftspeople, the flyer was finished in a metallic brown ink.

Issey Miyake's tribeca store in New York was conceived as a hub bringing together various creatives to produce an ever-evolving space. Product, architecture and communication combine in a unique visual experience, one which we have extended into printed form in this first publication from the store: the catalogue. We have designed the catalogue with an original die-cut "book within a book" feature that plays with image crop, text and image associations, and combinations between different parts of the whole.

We selected artists, musicians and designers, some never before shown in the US, to show alongside key products selected from the brands that the store carries. We were limited by pre-existing photo shoots, mainly catwalk or sample shots, and we used this limitation as an inspiration by treating the imagery in a radical, highly decorative way. The resultant mix reads like — a scrapbook of invention and cross-pollination, from the cover showing the store's titanium structure to the unique modern tribal portraiture of Ian Wright exhibited as wall murals.

made in clerkenwell letterforms

examples of typeface

idn special 03:
examining the visual culture of corporate identity
research studios / london

idn special 03:
examining the visual culture of corporate identity
research studios / london

spreads from issey miyake catalogue

143

idn special 03:
examining the visual culture of corporate identity
research studios / **london**

branded cover for catalogue

144

idn special 03:
examining the visual culture of corporate identity
research studios / london

alexei tylevich

idn special 03:
examining the visual culture of corporate identity
alexei tylevich / los angeles

alexei tylevich

In addition to referring to individuality and distinct personality as a persistent entity, one of the definitions of "Identity" is that of a condition of being the same as something else.

The chosen theme for my contribution is the "identity crisis" that penetrates both personal and public spheres, as well as "identity aberrations", such as stolen identity, false identity, assumed identity, mistaken identity, etc.

The condition of being the same is imagined, misunderstood, lost, found, faked, or manufactured, perpetuating the notion of identity in its pure form. The resulting images are attempts to express these analytical notions in a visceral way.

idn special 03:
examining the visual culture of corporate identity
alexei tylevich / los angeles

idn special 03:
examining the visual culture of corporate identity
alexei tylevich / los angeles

148
idn special 03:
examining the visual culture of corporate identity
alexei tylevich / los angeles

149

idn special 03:
the visual culture of corporate identity
alexei tylevich / los angeles

MEMPHIS

idn special 03:
examining the visual culture of corporate identity
alexei tylevich / los angeles

MEMPHIS ONLY

MEMPHIS ONLY MEMPHIS ONLY MEMPHIS ONLY

151
idn special 03:
examining the visual culture of corporate identity
alexei tylevich / los angeles

Dreams of LA

152
idn special 03:
examining the visual culture of corporate identity
alexei tylevich / los angeles

julian morey

idn special 03:
examining the visual culture of corporate identity
julian morey / london

julian morey

I've almost always approached identity from a typographic point of view — that is to say I'm often asked by the client to express everything about their business through the logotype.

Of course that's impossible as no logo or brand device can communicate everything that a business might want to say. On most occasions it's about choosing a solution that encompasses the best and hopefully most ingenious part of the company's trade.

However it's not always about making a typographic trick — more often it's about positioning the company within the correct cultural context. With Phillips Auctioneers the drop bar of the H acknowledges the company's heritage while the overall typographic design places it in the contemporary. Identity can go further than a brand device, for London Records I was invited to produce a series of large-scale images for their newly refurbished offices. Recordings made around London were processed through software to produce digital patterns, which in themselves reflect their content.

More recently I've been trying to break the mould of my logotypes; with Unclassics a specialist series of euro-disco re-issues which include the original track plus a remix. The idea was to create something with minimal means the flip of the N and A and uncomformist arrangement of letters says "look again you get something extra here".

phillips auctioneers
identity / logotype / typeface

ALBERS
BASQUIAT
CALDER
DUCHAMP
HALLEY
POLLOCK
RUSCHA

ABCDEFGHIJKLMNOPQRSTUVWXYZ
1234567890

PHILLIPS
AUCTIONEERS

155
idn special 03:
examining the visual culture of corporate identity
julian morey / london

london records corporate artworks

idn special 03:
examining the visual culture of corporate identity
julian morey / london

unclassics logotype

```
U
N        A
C    S    I
L    S C  S
```

idn special 03:
examining the visual culture of corporate identity
julian morey / london

cyberia cybercafé logotype

idn special 03:
examining the visual culture of corporate identity
julian morey / london

idn special 03:
examining the visual culture of corporate identity
julian morey / london

art + auction
magazine masthead

crocus.co.uk
logotype

twenty twenty-one Inc.
logotype

topman
logotype

Art
+Auction

crocus

20 21

TOPMAN

160

idn special 03:
examining the visual culture of corporate identity
julian morey / london

why not associates

idn special 03:
examining the visual culture of corporate identity
why not associates / london

why not associates

"I need some reference material for a meeting tomorrow. Can you get me that documentary that was on the telly the other night? y'know, the one on BBC or ITV... actually it might have been Sky... with the music that goes... DER DERDY DUM DY DER at the beginning. It used to be the theme tune for that kids programme, y'know, the Fligs... or Fluggles... or something. They were pink... they had long floppy ears and squeaky voices. One of them went to prison. They were big in the early or late 60s. Or was it the 70s? y'know, they were in that programme presented by... y'know, the woman with the beads, blonde hair, smiled a lot... y'know, she went out with that nutter, y'know... the lead singer of... y'know, six of them... one played maracas. They had that No. 1. They did that video with the gecko in it. It was used in that commercial, y'know... the one for sliced bread... or yoghurt... or jeans. It was directed by, y'know... big bloke, beard... he went into movies, y'know... he did that war film in the desert with the giant soldier ants... or were they termites? y'know... the ones with the tank crushing mandibles. Actually, they might have been armoured cars, they could have been bed bugs, she may have had black hair and a little voice inside my head is saying, The Floogies... or was it the Flergs?"

Y'know are a research company working mainly for clients involved in advertising and film production. They are constantly being asked to find things from their extensive library of films, documentaries, music promoos, music CD's and refernce books covering film, music, television, fashion etc.

Each application of the corporate identity was designed to illustrate a genre they may be asked to research from gay icons to death metal bands.

detail of address label / red light districts

SoHo

Patpong

Reeperbahn

Yoshiwara

reverse of compliments slips / top left - romantic novels / top right - golden boots

Lady in Waiting	Ride the Winter Wind	Ever a Princess	Dream Island	Claiming the Highlander	Promise of Gold	The Fire Inside
Pride and Prudence	The Doctor's Homecoming	Shades of Gray	To Kiss a Spy	Melanie Jackson	Hannah's Vow	Promise the Moon
The Carpetbagger's Wife	Lost in Your Arms	Too Wicked to Love	Highland Hearts	The Bride Thief	Danger's Promise	His Lady Fair

Anal Blast	Sinister	Crack Up	Cannibal Corpses	Enforsaken	Brutal Noise	Dead Jesus
Slaughter of Souls	Thy Serpent	Victims of Internal Decay	Vader	Sadistic Intent	Vomit Remnants	Famine
Suffocation	The Insomnia	Twin Obscenity	Slayer	Six Feet Under	Internal Bleeding	Hate

idn special 03:
examining the visual culture of corporate identity
why not associates / london

reverse of compliments slips / bottom left - death metal bands / bottom right - war films

GUILLERMO STÁBILE (ARG)	OLDRICH NEJEDLY (CZE)	LEONIDAS (BRA)	ADEMIR (BRA)	RONALDO (BRA)	FONTAIN (FRA)	VALENTIN IVANOV (SOV)
LEONEL SANCHEZ (CHI)	FLORIAN ALBERT (HUN)	VAVA (BRA)	DRAZAN JERKOVIC (YUG)	EUSEBIO (POR)	GERD MÜLLER (GER)	GRZEGORZ LATO (POL)
MARIO KEMPES (ARG)	PAOLO ROSSI (ITA)	GARY LINEKER (ENG)	SALVATORE SCHILLACI (ITA)	HRISTO STOITCHKOV (BUL)	OLEG SALENKO (RUS)	DAVOR SUKER (CRO)

m*a*s*h	colditz	hamburger hill	apocalypse now	enemy at the gates	pearl habour	carry on sergeant
full metal jacket	who dares wins	the deer hunter	saving private ryan	heaven and earth	zulu	born on the fourth of july
bridge over the river kwai	escape to victory	platoon	the battle of britain	the dambusters	das boot	tenko

165

idn special 03:
examining the visual culture of corporate identity
why not associates / london

vhs label disaster movies
why not associates / london

y'know	y'know	71 beak street london W1F 9SP tel +44 (0)20 7439 4780 fax +44 (0)20 7439 4775 enquiries@yknow.com	... DISASTER MOVIES

LOST FLIGHT	HARD RAIN	MAY DAY 40 000FT	TITANIC	PERFECT STORM	FLOOD	JAWS
SURVIVE	ABANDON SHIP	FINAL VOYAGE	THE POSEIDON ADVENTURE	THE RAINS CAME	THE SHIP THAT COULDN'T STOP	TIDAL WAVE

166

idn special 03:
examining the visual culture of corporate identity
why not associates / london

TITANIC	PERFECT STORM	FLOOD
THE POSEIDON ADVENTURE	THE RAINS CAME	THE SHIP THAT COULDN'T STOP

167

idn special 03:
examining the visual culture of corporate identity
why not associates / london

umatic label gay icons

y'know

y'know
71 beak street london W1F 9SP
tel +44 (0)20 7439 4780 fax +44 (0)20 7439 4775
enquiries@yknow.com

... GAY ICONS

| Oscar Wilde | Kenny Everett | Liberace | Boy George | Larry Grayson | Dale Winton | Tinky Winky |
| Rupert Everett | Julian Clary | George Michael | Marc Almond | Elton John | Quentin Crisp | Will Young |

Larry Grayson

Dale Winton

Tinky Winky

Elton John

Quentin Crisp

Will Young

idn special 03:
examining the visual culture of corporate identity
why not associates / london

credits

2gd / 2 graphic design a/s
wilders plads 8A, dk-1403 copenhagen k
t. 45 3295 2322 **f.** 45 3295 2321
www.2gd.dk

philippe apeloig
41 rue la fayette, F-75009 paris
t. 33 (0)1 43 55 34 29 **f.** 33 (0)1 43 55 44 80
www.apeloig.com

bark
studio 2, east block, 38 mount pleasant,
panther house, london, wc1x 0ap
t. 44 (0)20 7837 3116 **f.** 44 (0)20 7837 3116
www.barkdesign.net

base
rue de la clé 5, 1000 brussels / belgium
t. 32 2 2190082 **f.** 32 2 2293160
www.basedesign.com

cahan & associates
171 second st, fifth floor
san francisco, ca 94105
t. 1 415 621 0915 **f.** 1 415 621 7642
www.cahanassociates.com

epoxy
506 mcgill, 5e étage, montréal,
québec, canada h2y 2h6
t. 1 514 866 6900 **f.** 1 514 866 6300
www.epoxy.ca

imaginary forces
6526 sunset blvd, hollywood, ca 90028
t. 323 957 6868
www.imaginaryforces.com

foundation 33
33 temple street, london e2 6qq
t. 44 (0)20 7739 9903 **f.** 44 (0)20 7739 8989
www.foundation33.com

graphic thought facility
23–24 easton street, london wc1x 0ap
t. 44 (0)20 7837 2525 **f.** 44 (0)20 7739 0909
www.graphicthoughtfacility.com

iso design
floor 1, no.3 royal exchange court
17 royal exchange square, glasgow g1 3db
t. 44 (0)141 572 9150 **f.** 44 (0)141 572 9151
www.isodesign.co.uk

the kitchen
52-53 margaret street, london w1w 8sq
t. 44 (0)20 7291 0880 **f.** 44 (0)20 7291 0881
www.thekitchen.co.uk

open
180 varick street, room 822
new york ny 10014 usa
t. 1 212 645 5633 **f.** 1 212 645 8164
www.notclosed.com

sagmeister inc.
222 west 14 street, #15a
new york, ny 10011 usa
t. 1 212 647 1789 **f.** 1 212 647 1788
www.sagmeister.com

sea design
70 john st, london ec1m 4dt
t. 44 (0)20 7566 3100 **f.** 44 (0)20 7739 8989
www.seadesign.co.uk

segura inc.
1110 north milwaukee avenue
chicago, illinois 60622 usa
t. 1 773 862 5667 **f.** 1 773 862 1214
www.segura-inc.com

spin
12 canterbury court, kennington park
1-3 brixton road, london sw9 6de
t. 44 (0)20 7793 9555 **f.** 44 (0)20 7793 9666
www.spin.co.uk

research studios
94 islington high street
london n1 8eg
t. 44 (0)20 7704 2445 **f.** 44 (0)20 7704 2447
www.researchstudios.com

alexei tylevich/logan
3222 glendale blvd,
los angeles,ca 90039 usa
t. 1 323 906 1745
www.hellologan.com

julian morey
studio 116, 31 clerkenwell close, london ec1y 8sa
t. 44 (0)20 7336 8970
www.eklektic.co.uk

why not associates
22c shepherdess walk, london n1 7lb
t. 44 (0)20 7253 2244 **f.** 44 (0)20 7253 2299
www.whynotassociates.com

IdN Special 03:
Examining the Visual Culture
of Corporate Identity

ISBN: 988-97065-5-5

2003/04 First edition
Published by Systems Design Limited
Shop C, 5 - 9 Gresson Street, Wanchai, Hong Kong
Tel (852) 2528 5744 Fax (852) 2529 1296
www.idnworld.com

Publisher: Laurence Ng
Editor: Bill Cranfield
Assistant Editor: Chloe Tang
Editorial Assistant: Alva Wong
Senior Designer: Bryan Leung

Guest Art Director: Chris Kelly
mono design studio
www.monosite.co.uk

Business Manager: Portia So
Marketing Executive Assistant: Grace Li
Circulation Manager: Flora Kwok
Production Manager: Ngan Kwok Man

Film Output and Scanning: Commercial Prints
Tel (852) 2528 5311 Fax (852) 2529 1296

Periodicals postage is paid at Rahway, NJ.
POSTMASTER send address corrections to, IdN,
c/o Mercury Intl. 365 Blair Rd, Avenel, NJ 07001.
Distributed in the US by Mercury Intl., 365 Blair Rd,
Avenel, NJ 07001. USPS#019-882.

Paper supplied by:
Hing Tai Hong Paper Ltd.
Finnish Matt Art Paper - Lumi Silk 130gsm
Swedish Woodfree Paper - Multifine 100gsm

Submissions: IdN is pleased to receive any information
on new and interesting products but is under no
obligation to review or return unsolicited products
or material.

Copyright © 2003 by Systems Design Ltd.

All rights reserved. No part of this publication may
be reproduced in any form or by any electronic or
mechanical means, without written permission from
the publisher.